Narelle Jubelin

Narelle Jubelin

Soft Shoulder

THE RENAISSANCE SOCIETY AT THE UNIVERSITY OF CHICAGO
MAY 4, 1994 — JUNE 26, 1994

GREY ART GALLERY & STUDY CENTER, NEW YORK UNIVERSITY
JANUARY 20, 1995 — FEBRUARY 28, 1995

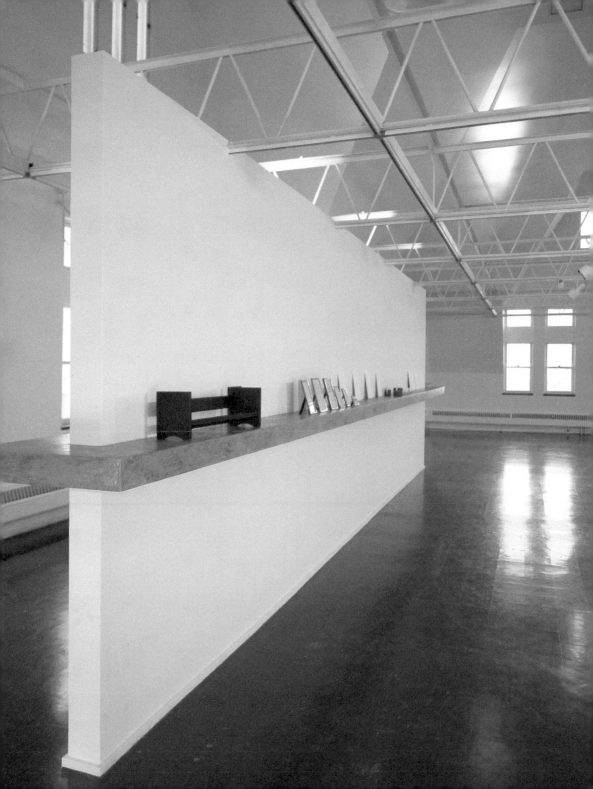

ACKNOWLEDGMENTS

It is with great pride and pleasure that The Renaissance Society at The University of Chicago and the Grey Art Gallery & Study Center, New York University, present the American museum premier of work by Australian artist Narelle Jubelin.

Jubelin's *Trade Delivers People,* an installation for the 1990 Venice Bienale, combined highly accomplished and labor-intensive petit-points with Ivory Coast masks, a New Guinea Bride Price Armlette, Venetian lace, and Australian coins to address the notion of cultural exchange and the way materials and philosophies of local cultures become globally transported, commingled, and distorted. This transformation of objects and information through exchange continues in Jubelin's first American exhibition.

Soft Shoulder, conceived for The Renaissance Society at The University of Chicago and the Grey Art Gallery & Study Center, New York University, revolves around the unpublished autobiography of Marion Mahony Griffin, an architect who worked in Frank Lloyd Wright's Chicago office before marrying Walter Burley Griffin, another distinguished architect working in Chicago at the turn of the century. Most appropriately, one version of Marion Mahony Griffin's manuscript *The Magic of America* is in the collection of the Ryerson Burnham Libraries of the Art Institute of Chicago, and the other is part of the New York Historical Society collection. Juxtaposed in Jubelin's cross-referential style is a body of correspondence between Anaïs Nin and Australian writer and bookseller/publisher David Pepperell. The thousands of threads and diverse objects that comprise *Soft Shoulder* slow down both viewer and images, begging us to reconnect them to their textural and textual origins.

This catalogue represents a collaboration between The Renaissance Society and the Grey Art Gallery & Study Center. It features essays by art historians Mary Jane Jacob and Russell Lewis from Chicago and Juliana Engberg of Melbourne. The professional collaboration of marital partners Lewis and Jacob echoes the professional relationship between the Griffins. We appreciate their willingness to risk this format and its associations. Juliana Engberg, Senior Curator at the Museum of Modern Art, Melbourne, furthers the intertextual reading by contributing books to the structure laid in place by Lewis and Jacob.

At The Renaissance Society, the exhibition and catalogue are supported in part by the National Endowment for the Arts, a federal agency; the Illinois Arts Council, a state agency; the CityArts Program of the Chicago Department of Cultural Affairs, a municipal agency; and by the Society's membership. Program support has been received from Qantas Airways Limited, Regents Park by The Clinton Company, The John D. and Catherine T. MacArthur Foundation, and the

Andy Warhol Foundation for the Visual Arts. Indirect support has been received from the Institute of Museum Services, a federal agency offering general operating support to the nation's museums. Generous private support has been provided by Daryl E. Gerber. The catalogue was assisted by the Commonwealth of Australia through the Embassy of Australia, Washington, D.C., and The Elizabeth Firestone Graham Foundation. Research for *Soft Shoulder* was assisted by the Australia Council, the Australian federal government's arts funding and advisory body.

At each venue, the exhibition has been realized through the collective efforts of many individuals. At the Grey Art Gallery exhibitions and publications are made possible with the support of the Abby Weed Grey Trust and the Friends of the Grey Art Gallery. The staff of the Grey Art Gallery — Frank Poueymirou, Associate Director; Wendell Walker, Gallery Manager; Michele M. Wong, Registrar; Mary-Beth Shine, Administrative Assistant; Deborah Whitney, Preparator; and Tamar Cohen, Jason Rosenthal, Seema Srivastava, and Ana-Maria Stanomir, Work-Study Assistants — all contributed to the success of the exhibition.

At The Renaissance Society thanks are extended to Randolph Alexander, Development Director; Hamza Walker, Director of Education; Karen Reimer, Registrar and Preparator; Patricia Scott, Bookkeeper and Secretary; Louis Brandt, Farida Doctor, and Lisa Meyerowitz, Work-Study Assistants; and Gary Gordon, Elizabeth Riggle, Donna Schudel, Christopher Scott, and Margaret Wade, installation crew. Initial work on the publication was begun by Joseph Scanlan, and we thank him for his assistance.

We also wish to thank Hamza Walker, of The Renaissance Society, and Jean Fulton, editors of this publication, along with designers Jason and Leslie Pickleman of JNL Graphic Design, Chicago, and photographer Tom van Eynde for their careful work on this catalogue.

On behalf of Narelle, we extend special words of thanks to Gunther Stuhlmann, office representative on behalf of the Anaïs Nin Trust, for permission to use excerpts from *The Diary of Anaïs Nin* and to Javant Biarujia of Nosukumo publishers for permission to use correspondence from *Letters to a friend in Australia*. Thanks also go to the following individuals: Michelle Andringer, Phillip Boulten, Maureen Burns, Jenepher Duncan, Annette Holder, Jo Holder, Scott Hayes, Satoru Itazu, Elizabeth Gertsakis, Geoff Kleem, Stephen Mori, David Pepperell, Gregory Ralph, Andrew Renton, Anna Rubbo, Paul Saint, Joe Scanlan, and John Vinci as well as to the following galleries and institutions: the Mori Gallery, Sydney; Monash University Gallery, Melbourne; and the Mary and Leigh Block Gallery, Northwestern University, Evanston. Their generous support greatly strengthened the exhibitions and this publication.

Finally, our acknowledgment goes to Narelle Jubelin for the work, pleasure, and inspiration her art continues to give us.

Susanne Ghez, Director
The Renaissance Society at The University of Chicago

Thomas W. Sokolowski, Director
Grey Art Gallery & Study Center

RUBBING SHOULDERS:

Free association is the delight of good friends

JULIANA ENGBERG

NOTES
With thanks to Narelle Jubelin,
Margaret Plant, Jane Shepherd,
and Louise Stirling.

Copper plates, personal correspondence, ceramic vessels, shop signs, women's hosiery, crockery, an original oil painting, fragments of a manuscript, and a self-portrait all arranged on a shelf in an interior. Narelle Jubelin's projects deal with objects: found, made, prepared; chosen, researched, re-presented. Arranged in narratives of time and space, they are weighty with their own material and history, so that critic Andrew Renton can remark with a certainty that the objects "are allowed to become the sum of their own travels and existence in time,"[1] and writer Elizabeth Gertsakis can emphasize that Jubelin's "fragments also exist as pure translations of tradition and beg the question of knowledge..."[2] Supporting these statements is the synchronicity of Jubelin's projects with a general theoretical reacquaintance and rereading of Walter Benjamin's *Das Passagen-werk*.

1. Andrew Renton, "Narelle Jubelin," Centre for Contemporary Art, Glasgow, (review), *Flash Art*, vol. XXV, no. 166, October 1992.

2. Elizabeth Gertsakis, "A Pure Language of Heresy: The work of Narelle Jubelin," in *BINOCULAR: Focusing Material Histories* (Sydney: Moët & Chandon, Contemporary Edition/Edition Contemporaine, 1993).

In this reading of Jubelin's *Soft Shoulder* installation, I am interested in the *non*-existence of Benjamin's *Das Passagen-werk*. Certainly its structural outlines and fragments have been translated and published and subsequently analyzed and theorized, but the book that Benjamin imagined as the final result of these notations does not exist. Benjamin, as we know, never had the opportunity to complete the task he had set himself. The fragments of the project that would become *Das Passagen-werk*, as we have come to know it, are traces — pieces of evidence that require the perception and intuition of a detective to unravel their mysteries and meanings. Since *Das Passagen-werk* concentrated on the materialist view of history provided through objects located in the interior worlds of the Paris arcades, it seems appropriate to remind ourselves of one particular fragment — Benjamin's *Paris - the Capital of the Nineteenth Century* — in which he develops his theory of objects and interiors as traces of living.

> Living means leaving traces. In the interior, these were stressed. Coverings and antimacassars, boxes and castings, were devised in abundance, in which the traces of everyday objects were moulded. The resident's own traces were also moulded in the interior. The detective story appeared, which investigated these traces. *The Philosophy of Furniture*, as much as his detective stories, shows Poe to have been the first physiognomist of the interior. The criminals of the first detective novels were neither gentlemen or apaches, but middle class private citizens.[3]

3. Walter Benjamin, *Charles Baudelaire: A Lyric Poet in the Era of High Capitalism*, trans. Harry Zohn (London: Verso, 1976), 169.

Before beginning this essay, I decided to avoid Benjamin, because Jubelin's work has been so consistently linked to his materialist histories and philosophies. I am, however, forced to revise that decision, for of paramount importance to this parallel text is the idea of the detective and the detective novel developed out of a physiognomist interpretation of the interior and its contents. If we view *Das Passagen-werk* as an interior space for Benjamin, it would correlate to the residual traces of Benjamin's body as it walks about the Paris arcades observing the objects of a

passing era; a body, both corporeal and metaphoric, which is — as is requisite in the plot of the detective genre — missing.

Benjamin has described the methodological path and it is in this spirit then, in the spirit of the sleuth, that I approach Narelle Jubelin's installation, *Soft Shoulder*, ready to read the traces and noticing at once its provocatively physiological title. A kind of a dame of a title. The kind of a title that could walk into a Raymond Chandler interior and announce its complicitness while smoothing out its stockings. Stockings. Didn't Benjamin say the "methodological relationship between the metaphysical investigation and the historical one: ...[was]... a stocking turned inside out"? [4]

It is important that these stockings are mechanically made, machine knit-

4. Susan Buck Morss, *The Dialectics of Seeing: Walter Benjamin and the Arcades Project* (Cambridge: MIT Press, 1991), 21.

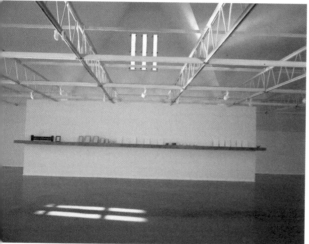

ted, the better to reinforce the age of mechanical reproduction that makes possible the progressive montage underscoring the organization of *Das Passagen-werk* fragments and is the formal precursor to Jubelin's object collage. So let's smooth on the stockings and play this game of object and association.

Or, borrowing from Gertrude Stein, let us think about

OBJECTS
Within, within the cut and slender joint alone, with
sudden equals and no more than three, two in the
centre make two one side.
If the elbow is long and is filled so then the best
example is all together.
The kind of show is made by squeezing. [5]

5. Gertrude Stein, *Tender Buttons: Objects, Food, Rooms* (Los Angeles: Sun & Moon Classics, n.d.), 21.

It seems to me there are several bodies *not* here, but traces of many — squeezing. Some are named, some are well and truly hidden in the montage of things. Some of the named are writer Anaïs Nin, author of her own traces in her seven-volumed *Diary*; architect Marion Mahony Griffin, author of her own account of the life and work she shared with husband Walter Burley Griffin; and designer Susie Cooper, creator of ceramic ware for the mass market. The dames of the story.

The importance of these feminine traces should not be underemphasized. While the impulse to detect has been borrowed from Benjamin, and the interiority that he first discussed has its origins in the rooms of the men of modernity, this slender joint is clearly sexualized as female. To note the very significant shift Jubelin has made, we need only contemplate briefly the architectural bodegones of Le

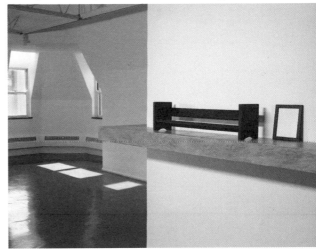

Corbusier's *Villa Savoye*, with their masculine traces of hat, glasses, cigarettes, and lighter,[6] to register her very different object palette. So it is to the feminine voices we must attend if we are to unravel this detective story.

Like any detective I need a hook, a thing on which I can pin my clues in a different order to the way they are presented at the scene. I notice a book rack. It is described as a "stained wooden book rack, Australian c. 1910. 9" x 2' 9 1/2" x 7 1/4", purchased in Sydney 1986 as a birthday gift for a friend, 1/19/86." Well, now we know what happened on the day 1/19/86. A woman went shopping for a gift for a friend. Friends are accommodating, so let us make use of that and use the book rack as the hook.

And I need a witness, someone willing to offer clues and give me their narrative version of events and things. I can think of no one better for this important role than Anaïs Nin.

6. See illustration and read analysis provided in Beatriz Colomina, "The Split Wall: Domestic Voyeurism," in *Sexuality & Space,* Princeton Papers on Architecture (New York: Princeton Architectural Press, 1992).

It is bitterly, bitterly cold. From the 14th floor I see the NYC University, a library being built, a few small galleries, the Eye Magazine headquarters; and to the left Bleeker Street, heart of the Village, with a moving picture house, night clubs, rock and roll, boutiques, and as many politicians as hippies! [7]

7. David Pepperell, *Anaïs Nin: Letters to a friend in Australia* (Melbourne: Nosukumo, 1992), 20.

Empty, a book rack awaits fulfilment. It awaits a package dispatched from New York. A parcel that will take six weeks. Time delivers ideas. Indeed, a library is being built, a library that will occupy a book rack in Australia in the late '60s. It is a small personal library, not unlike one of the small galleries visible from the fourteenth-floor apartment, with just a few selected things. On its single shelf will

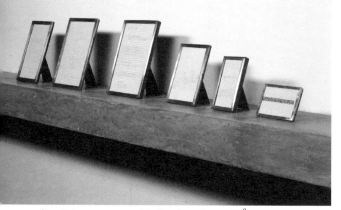

be, "Have you read Julio Cortázar...?" [8]

8. Ibid., 16.

In her generous, often repetitious, but always deeply pulsed letters to her Australian correspondent David Pepperell, which are represented in *Soft Shoulder* as thirty silver-point transcriptions, Anaïs Nin introduces South American, Paris-based writer Cortázar. Cortázar is best known for *Hopscotch* and *End of the Game,* among other short stories, but is possibly best unknown as the writer of *Blow-Up,* a film that launched director Antonioni and limpid-eyed actor David Hemmings (the photographer) into our '60s consciousness. Cortázar is hidden in the text like a faint clue in the photographic grain of Hemmings' black-and-white pictures. And so, in our book rack, beside Cortázar's collected stories, let us have the video of Antonioni's *Blow-Up.*

Naturally the quest to make legible the clue that will give clarity to the

pivotal moment in the film *Blow-Up* is analogous to the task undertaken by the detective-viewer of Jubelin's projects, as they zoom in on the various details then pan out to see where the item fits. And, like Nin, Jubelin leads her audience to the moment by making the clue visible. Letting it be seen all the time in the object while knowing it is difficult to decipher. The very accuracy and clarity of Jubelin's descriptions, so benign in their straightforwardness, cause a sensation of doubt. There must be more to it than that. They must have a greater significance than mere presence. Indeed, "the sum of their own travels and existence in time" and their presence "as pure translations of tradition" that "beg the question of knowledge" render Jubelin's objects dense with the legibility of minute interweaves, whether they be anatomical particles, photo dots, or petit-point. I can well imagine,

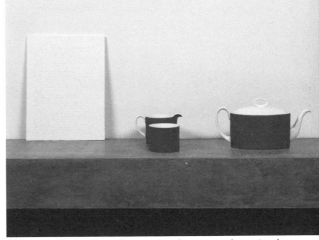

for instance, the young David Pepperell, reading the preciously sent and received Cortázar so carefully as to make his brows knit in an effort to home in on the special message embedded in the text, the message Anaïs Nin, the poet seductress, wants him to understand.

9. Julio Cortázar, *Blow-Up and Other Stories* (New York: Random House, 1967), 114.

It will never be known how this has to be told, in the first person or in the second, using the third person plural or continually inventing modes that will serve for nothing.[9]

Here, Cortázar states both the methodological and formal proposition which will concern the viewer in encountering *Soft Shoulder*, with its choir of voices and its points of view, from the detail to the panorama. Jubelin uses the ploy of multiple narratives in the first person, second person, and third-person plural. Nin also employs the strategy of several voices and shifts views from Los Angeles

to New York, squeezing other locations like "Greece, Majorca, Turkey, Moro-rocco"[10] into the envelope of a sentence, the better to emphasize their mystery, as does her Sabina in the novella *A Spy in the House of Love*. Another book for our library.

> It was now as before in the Paris exhibits, all the methods of scientific splitting of the atom applied to the body, and to the emotions. His figures exploded and constelled into fragments, like spilling puzzles, each piece having flown far enough away to seem irretrievable and yet not far enough away to be dissociated. One could, with an effort of the imagination, re-construct a human figure completely from these fragments kept from total

10. Pepperell, 23.

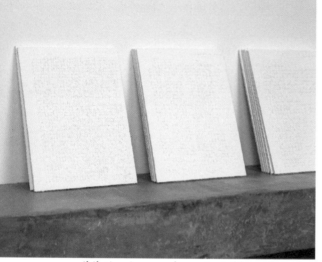

> annihilation in space by an invisible tension. By one effort of contraction at the core they might still amalgamate to form the body of a woman.[11]

11. Anaïs Nin, *A Spy in the House of Love* (London: Penguin, 1973), 99.

But for the reference to "the body of a woman" one might have returned to *Das Passagen-werk*. Instead, to our book rack I will add Marcel Duchamp's *Boîte-en-valise,* which serves as a bridge between the handmade arcade object and the manufactured object of modernity. Because we must not lose sight of Jubelin's work as part of the trade of art and objects, *Boîte-en-valise* is placed here also as a reconciliation between the readymade and the art historically classified, and therefore renewed, readymade (assisted, aided, rectified, or modified),[12] which makes up the sum of the work of the bride Rrose Sélavy. In other words, the body of a woman, so absolutely the project of Duchamp's depiction and manifestation. *Boîte-en-valise,* which makes travel possible, which delivers objects with art-

12. Carol P. James, "An Original Revolutionary Messagerie Rrose" in *The Definitively Unfinished Marcel Duchamp*, ed. Thierry De Duve (Cambridge: MIT Press, 1991), 283

historical nomenclature. A suitcase for the quick-change artist. And there, with all its salacious intent, is the object which stands in for everything and nothing: the little replica *fountain*. For what is *fountain* if not the body of a woman, not Courbet's *Origin of the Universe* or Leonardo's *Mona Lisa*?

It is perhaps as well as these things, PLUMBING.

What were the grounds for refusing Mr. Mutt's fountain:
1. Some contend it was immoral, vulgar.
2. Others, it was plagiarism, a plain piece of plumbing.

Now Mr. Mutt's fountain is not immoral, that is absurd, no more than a bath tub is immoral. It is a fixture that you see every day in plumber's show windows.

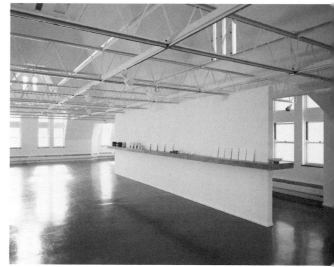

13. Ibid., William Camfield, "Duchamp's Fountain: Aesthetic Object, Icon, or Anti-Art?", 145. The author of this piece of clarifying aesthetic mischief appears to be Beatrice Wood adding yet another voice to this assembly. And another woman to the scene. The adventure of the readymade is everywhere And everywhere it emerges in this project as the body of a woman, in the first, second, third-person plural. For what lies underneath the *Boîte-en-valise* but a folded photograph of the first Rrose readymade, *Why not sneeze?*; but the photograph is pasted down. Cannot be lifted and cannot be seen. The name Rrose is hidden. The mystery continues.

Whether Mr. Mutt with his own hands made the fountain or not has no importance. He CHOSE it. He took an ordinary article of life, placed it so that its useful significance disappeared under the new title and point of view — created a new thought for that object. As for plumbing, that is absurd. The only works of art America has given are her plumbing and her bridges.[13]

Jubelin too creates new thoughts for her objects, but she does not give them new titles. Rather, the new thoughts come as a result of our interpretation, not hers. This is what Gertsakis means by begging the question of knowledge. And a little knowledge can be a dangerous thing. In this way Jubelin's project problematizes our certainty about the readymade and the found object. Hers is a project that leaves gaps for new interpretations while steadfastly denying the need. A project

that activates a question about her intentionality. Perhaps, for instance, the objects in her installations are merely the paddle to which Hemmings is attracted, which leads us to the central story in *Blow-Up*.

Narelle Jubelin tells a very funny story about purchasing her PLUMBING sign in Chicago. As she is walking down the street after buying it (one imagines the letters PLU and ING visible from either side of her arm), people stopped her and asked if she was available to work. In Australia plumbing is used as slang for the internal organs of the female body. When the plumbing gets clogged up you're in strife, as they say. The solicitation of availability takes on new definitions with this piece of information under our arms. Perhaps this is why Jubelin was particularly pleased when, recently in conversation, Elizabeth Gertsakis mentioned Visconti's

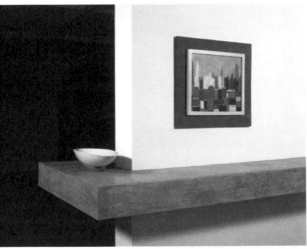

film *The Damned*, in which a woman climbs up onto a mantelpiece and fucks the art deco ornaments.

The notion of plumbing as the infrastructure that provides the possibility of the modern, utopian city announces its interest, as does the idea of plumbing as a kind of flow chart for the circuitries of art objects; from the flush of the Duchampian urinal to the waterfall in *Etant donnés* to Gober's wash basin, for instance. But most particularly, in this scenario, I am attracted to PLUMBING for its language function as an allusion to organs and pipes, describing a form of organic corporeality.

If PLUMBING can stand in as a form of sexualized interiority, then Jubelin's *Soft Shoulder* does indeed nudge at the distinct erogenous zones of modernism. *Soft Shoulder* alters once and for all the dominance of Benjamin's melancholic male and asserts the feminized modern interior space, characterized, as

always, by hidden libidos, rich fantasies, and longings that are to be found in Jubelin's object traces.

I am attracted to the large round plates: "Four copper-beaten plates purchased as attributed to the Hull-House Chicago c. 1910. I don't care a great deal whether these plates are authentically Hull-House or not, since, not being a Chicagoan, it is all notional anyway. I am more interested in the way they connect to the hidden libidos, rich fantasies and longings that play a part in the fall from grace of William Issac Thomas, professor of sociology at the University of Chicago and author of *The Unadjusted Girl*, a sociological study that charts the "female story of migration and change from pre-modern, rural traditional, ethnic community to modern, urban freer, often deviant society."[14] It is a study which, although

14. Carla Cappetti, *Writing Chicago: Modernism, Ethnography and the Novel* (New York: Columbia University Press, 1993), 74.

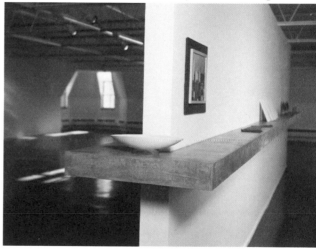

a human drama, mirrors Benjamin's thoughts on objects in their time travel from pre-modernity to modern times. Another book for the book rack.

Associated with Jane Addams, Hull-House, and the suffragist movement of Chicago, Thomas's investigations into the evolving modern woman, with her desire for sexual and economic mobility, cast him in the role of deviant, especially in the eyes of the press and the university after the discovery of his affair with a Mrs. Granger in the Loop Hotel in Chicago. A fallen man, Thomas was discredited and denounced by the university, so much so that the absence of the personal papers of such a prominent man in the history of the University of Chicago and its fledgling sociology department has led historian Janowitz to suggest that it appears "as if there may have been an effort to obliterate the record of W I Thomas as a man."[15] Thomas is therefore relegated to the position of his "Unadjusted Girls" and defined as they are, according to his research and narratives, in the modern world, "in a

15. Ibid., quoting Janowitz, 89.

space defined by two axis: on one side is a theory of human behaviour that relies on psychological, anthropological and physical concepts; and on the other is the theory of social change that narrates the decline of the old world and the rise of modern society."[16]

16. Ibid., 75.

I am impressed by the analogy this provides for the structure of Jubelin's wall and objects. And for the way it provides information about yet another woman — Thomas's case history of Margaret, who "with a kind of aesthetic logic (had come) to Greenwich Village" to seek a more meaningful sense of herself.

> I had been looking for Margaret, for I knew she was a striking instance of the "unadjusted" who had within a year come with a kind of aesthetic

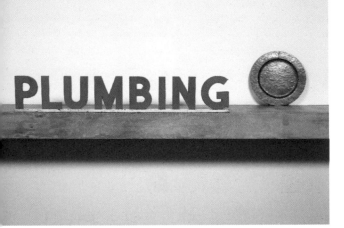

> logic to Greenwich Village. She needed something very badly. What I heard about her which excited me was that she was twenty years old, unmarried, had never lived with a man or had any of that experience, had worked for a year on a socialist magazine, was a heavy drinker and a frequenter of Hell Hole...[17]

17. Ibid., p86.

Thomas's narrative descriptions of his case studies find their corollary in Anaïs Nin's character Sabina in *A Spy in the House of Love*, who walks the New York streets and frequents the Mambo Night club, only to discover an appreciation of modern aesthetics. "For the first time, on this bleak early morning walk through New York streets not yet cleaned of the night people's cigarette butts and empty liquor bottles, she understood Duchamp's painting *A Nude Descending a Staircase*. Eight or ten outlines of the same woman, like many multiple exposures of a woman's personality, neatly divided into many layers, walking down the stairs in unison."[18]

18. Op cit., Anaïs Nin, *A Spy in the House of Love*, 112.

Jubelin's project is one that also proposes a kind of aesthetic logic by providing multiple outlines of the feminine personality in an adventurous unison — the split, or the two-facedness, that is evident in the embossed self-portrait, for instance, or the canny design principle that is evident in Susie Cooper's '60s ceramic ware, in which "a single matt colour contrasted with a white body; coloured cups in pimento...could be used in one colour services or co-ordinated with patterned pieces in complementary colours."[19] The sort of cup-and-saucer setting I imagine Anaïs Nin to serve coffee in when finally meeting the jittery Pepperell in her home designed by Eric Lloyd Wright.

19. Ibid., 73.

I am encouraged to ask, therefore, in the manner of a lesson, what's wrong

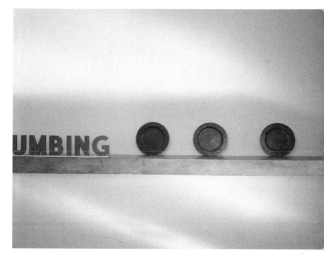

with this picture? What item amidst these personality-filled, meaningful feminine objects of tea cups, bowls, framed petit-points, silver-point transcriptions, book rack, plumbing sign, plates, and stockings is the jarring feature? And there, with its empty, uncertain, unlocatable, totally average appearance, is the painting of the exterior city. And there is the answer. A thin, nondimensional space of the exterior world as opposed to the captivating solidity of the interior.

In this arrangement it is a useful porthole, a window through which Anaïs Nin can gaze and see Washington Square, the Village, the Empire State Building; the better to state with certainty her preference for Mexico and Japan. It is a window through which one of *Soft Shoulder's* points of itinerary, the Grey Art Gallery building, is also visible as Nin takes a break from the dense world of her diaries and correspondence. The exterior world as portrayed in this generic modern-scape painting holds no pull, no fidelity to Nin's real/imagined/real experience contained in the pages of her vault.

We enter the predictable space of the art gallery only to encounter the radical domestication that has taken place. A single wall remains, in place of the usual several, and it has taken on the unmistakable form of a centralized domestic interior. Dominating the space is the shoulder-high shelf, which stands in as both a referent to the mantel in domestic architecture and to the new sculpture of the '60s, which turned its attention to the articulation of the wall and the relationship of the wall to the viewer. Positioned along the shelf, in a straightforward display, are the items of Jubelin's making and collection, the labels divulging provenance, also straightforwardly, unblinking like practiced cheats.

One begins to read the *petit-point* transcriptions from Marion Mahony Griffin's *The Magic of America* and the accompanying label which tells of two

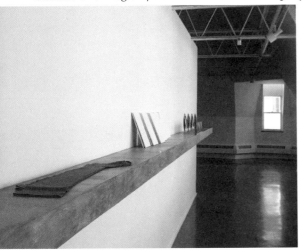

versions, each slightly different from the other, one held in Chicago, the other in the collection of the New York Historical Society. In reading one realizes this is an interior space made possible by another woman. The squeezing, as Stein would have it, of these exterior places, these cities coming together on this shelf of synchronicity, is made possible by the linear construct of Mahony Griffin's building designs and philosophy. It is the philosophy of Mahony Griffin, invented for her *House and Studio of a Painter,* which influenced Frank Lloyd Wright's design for his studio in Oak Park, Illinois,[20] and which eventually turned up in the domestic architecture that surrounds Anaïs Nin in Silver City, Nevada.[21]

We must add *The Magic of America,* in its four volumes, to our book rack, and it takes up a lot of space. This seems appropriate since it attempts to set down the utopian and modernist epic of the Griffins, which spans the colonial territories of Australia, India, and the United States, and is born, if you like, of the frontier

20. For an argument that Marion Mahony Griffin influenced Frank Lloyd Wright in the development of his Oak Park residence and studio, see James Weirick, "Marion Mahony at M.I.T.", *Transition: Discourse on Architecture*, No. 25, Winter 1988, Department of Architecture, RMIT, Melbourne, 1988.

21. David Pepperell, *Anaïs Nin: Letters to a friend in Australia*, 10,11.

22. Anaïs Nin, *A Spy in the House of Love*, 109.

— that unimaginable, but forever enticing, place that Anaïs Nin puzzles about: "I know so little about where you are I can't surround you with a landscape... I cannot imagine your place, landscape, books. Why does Australia seem so exotic?" [22]

To this question neither Jubelin nor I will provide an answer. Like the finale to *Blow-Up*, some things will be left undisclosed, and in the final analysis we will be left with reproductions, theories, and ideas that add up to a body of evidence but do not reveal the missing person. *Cherchez la femme?* This woman descending the modernist staircase, this woman walking the New York streets, this woman writing from India and Australia, this woman with the gas lamp, this woman without her stockings, this woman drinking coffee, this split personality — this body of a woman?

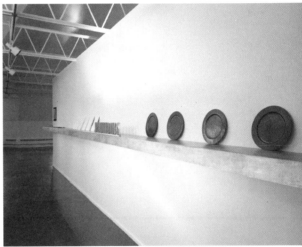

Jubelin toys with the genre of the detective novel, setting up a parlor game of clues. She has, as always, combined this with a willful resistance to interpretation, leaving her objects to speak their own material histories. My witness, Anaïs Nin, and her multiple female personalities are slippery and adept at leaving the scene and, like Jubelin, will not sign any confession, for, "As soon as Jay listened too attentively, she took a giant sponge and erased all she had said by an absolute denial as if this confusion were itself a mantle of protection."[23]

23. Anaïs Nin, *A Spy in the House of Love*, 109.

REFERENCES

Benjamin, Walter. *Charles Baudelaire: A Lyric Poet in the Era of High Capitalism* (trans. Harry Zohn). London: Verso, 1976.

Cappetti, Carla. *Writing Chicago: Modernism, Ethnography and the Novel.* New York: Columbia University Press, 1993.

Colomina, Beatriz. "The Split Wall: Domestic Voyerism" in *Sexuality & Space.* New York: Princeton Architectural Press, 1992.

Cortázar, Julio. *Blow-Up and Other Stories.* New York: Random House, 1967.

Eatwell, Ann. *Susie Cooper Productions.* London: Victoria and Albert Museum, 1987.

Gertzakis, Elizabeth. "A Pure Language of Heresy: The Work of Narelle Jubelin," in *BINOCULAR: Focusing Material Histories.* Sydney: Moët & Chandon, Contemporary Edition/Edition Contemporaine, 1993.

Morss, Susan Buck. *The Dialectics of Seeing: Walter Benjamin and the Arcades Project.* Cambridge: MIT Press, 1991.

Nin, Anaïs. *A Spy in the House of Love.* London: Penguin, 1973.

Pepperell, David. *Anaïs Nin: Letters to a friend in Australia.* Melbourne: Nosukumo, 1992.

Renton, Andrew. "Narelle Jubelin," *Flash Art*, vol. XXV no. 166, October 1992.

Weirick, James. "Marion Mahony at MIT," *Transition: Discourse on Architecture*, No. 25, Winter 1988, Department of Architecture, RMIT, Melbourne, 1988.

softshoulderbigshoulders

Chicago, July 1994

MARY JANE JACOB &
RUSSELL LEWIS

The following information, arranged by categories related to this
installation, is offered as one guide to the reading of its associations
and meanings.

floatingwallwallpainting
concreteshelf

woodbookrackdoubleself
portraitpetitpoint
renditionsninletters
bonechina

ceramicbowl

internationalstyle
paintingmachineknitted
stockingsplumbingsign
copperplates

AUSTRALIA

❶ A Workingman's Country
"In the early 1960s the number of white-collar workers exceeded, for the first time, the number of blue-collar workers and then streaked ahead....Australia, which had been regarded for so long as a workingman's country, 'the last stronghold of egalitarian democracy,' as American historian Hartley Grattan put it, had almost unnoticed transformed itself into one of the most middle-class nations in the world" *(Singapore 1988, 56).*

See:
Chicago Architecture
2. Democracy

Copper
3. Mining
4. Printing
6. Plumbing

Shoulder
2. Chicago

❷ Anti-Americanism
"The reluctance of the United States to enter World War I aroused wide-spread anti-American feeling within the Australian nation. Griffin, an American in Australia, had to take some of the brunt of it" *(Melbourne 1986, 86).*

Again in the late 1960s and early 1970s the bond between America and Australia, which had been strengthened by their alliance in World War II, was tested when Australians took exception to American intervention in Vietnam.

See:
Chicago Architecture
9. Walter Burley and
Marion Mahony Griffin

❸ Architecture
As practitioners of the Chicago School in Australia, "the Griffins brought their beliefs in architecture as a powerful force for the expression of philosophical principles..." *(Melbourne 1988, 15).*

The International Style spread throughout the world.

See:
Chicago Architecture
1. Modern Architecture
7. Prairie School
10. International Style

❹ Commonwealth Customs Censorship
"In the 1971 Australian Labor Party Conference a decision was made that 'the censorship laws were to conform to the general principles that adults be entitled to read, hear or view what they wish in private or public and that persons (and those in their care) be not exposed to unsolicited material offensive to them. For the purpose of implementing those principles a judicial tribunal was established to hold public hearings and to give published reasons. The Commonwealth laws for censorship of imported books, records and films to be altered accordingly.'

"On December 2, 1972 the Liberal Government was defeated in the general elections and under the Australian Labor Party administration Customs censorship became the responsibility of the Attorney General, Senator Lional Murphy....One of Senator Murphy's first acts in this field was to ask the National Literature Board Review to speed up its review of prohibited books with a view to early releases. The list of banned works included William S. Burroughs's *Naked Lunch*, Henry Miller's *Sexus*, Frank Harris's *My Life and Loves*, Andy Warhol's *Blue Movie*, Jean Genet's *Thief's Journal* and the unexpurgated editions of Gore Vidal's *Myra Brekenridge...*"*(Sydney 1974, 25).*

See:
Writing
7. Publishing

● References

self-portrait of an Australian; book rack, frame for self-portrait, silver frames for petit-points, and stockings purchased in Sydney; letters sent to Australia

AUTHENTICITY

❶ Evidence

Reliable, factual evidence is termed concrete evidence.

❷ Museum Interpretation

Museums aspire to common standards of scholarship and authentification. However, the same object is treated differently in an art museum when compared to a history museum. The former emphasizes aesthetic qualities within a chronological framework of changing styles, while the latter develops a cultural or social context. Contemporary artists have adopted the techniques of non-art museums to create personal interpretations of material culture. These installations are meaningful, but often their historical authenticity is suspect.

See: Concrete

❸ Artistic License

See: Copper
Decorative Arts
5. Hull-House

Artists are typically more interested in the symbolic quality of an object than its historical attributes. There is no reason to believe, no evidence whatsoever, that the copper plates are from Hull-House.

❹ Attribution to Marion Mahony Griffin

In her later years, Marion Mahony Griffin stippled out the name of her husband from some drawings.

See:
Chicago Architecture
8. Marion Mahony Griffin
Cities
2. Australian Capital
3. Castlecrag
5. Cities in India
Women
6. Marion Mahony Griffin
Writing
1. Autobiography

In her role as delineator for several male architects—Dwight Perkins, Frank Lloyd Wright, Hermann V. von Holst, and Walter Burley Griffin—Marion's distinctive monogram did not always appear on her work, and her contribution to the design of a commission is rarely clear.

Architects typically took credit for their delineators' renderings, but as one of the few women in a field dominated by men, Marion Mahony Griffin viewed this practice as even more pronounced and meaningful.

Although she admired her husband, she clearly wanted her creative talents recognized. On a drawing of the Henry Ford country home, Marion changed her title from "Marion M. Griffin, associate" to "Marion M. Griffin, designing

architect" *(Chicago 1966, 21)*. Perhaps she realized that museum curators, private collectors, and art historians will judge an architect by his or her drawings.

● **References**
a wood book rack that alludes to the one designed by Walter Burley Griffin from his deathbed; the artist's self-portrait; Walter Burley Griffin's signature, Walter Burley Griffin's signature stippled over by Marion Mahony Griffin, and frontis-piece for Marion Mahony Griffin's autobiography rendered in petit-point; a mismatched tea and coffee set; an anonymous painting in the 1950s style of abstraction depicting an unknown city; copper plates attributed to the crafts workshop at Hull-House; the suggestive arrangement of objects in the installation

CHICAGO ARCHITECTURE

❶ **Modern Architecture**
"Chicago is the national, and indeed the world, capital for historic landmarks of modern architecture. Almost the whole history of what we call contemporary design can be examined in Chicago. For Chicago is the birthplace of modern architecture....That is why architects come from all over the world to study these great buildings. Chicago is the urban center of the life and work of Frank Lloyd Wright and Ludwig Mies van der Rohe, who, along with Le Corbusier, are the great architects of our time. Another Chicagoan, Louis Henri Sullivan, was the master from whom Wright, Mies, and Le Corbusier drew inspiration in developing their talents and their understanding of the architect's role in society..." *(Chicago 1980, xi)*.

❷ **Democracy**
"And this, in the last analysis, is the power of these great Chicago buildings. They are a humane expression of a new way of life—the modern urban community based on money and technology...The love of the common man has been the glory of Chicago. The belief that only when he is decently housed can democracy survive has been the moral glory of our architecture. The conviction that he must be beautifully housed and sheltered has become the aesthetic credo of modern archi-tecture. Who to do this—the state, the businessman, or the powerful institutions of democratic community itself—is by no means certain. But that it must be done is certain. For democracy cannot exist without good architecture, and good archi-

tecture in turn can be treated only among men who walk the earth in freedom and dignity" *(Chicago 1980, xvii).*

❸ Louis Sullivan

Sullivan advocated the creation of an organic style, a new American architecture, an "architecture of democracy" that abandoned classicism and returned to nature. Irving Pond wrote about the developing indigenous American architectural design: "the horizontal lines of the new expression appeal to the disciples of this school as echoing the spirit of the prairies of the great Middle West, which to them embodies the essence of democracy" *(London 1991, 131).*

See:
Decorative Arts
5. Hull-House

❹ Frank Lloyd Wright

Wright left his position as a draughtsman in Sullivan's office in 1893.

His major innovation was to design open, interpenetrating interior spaces, to free the wall to define rather than enclose an area.

The horizontal Prairie Style house is anchored by massive vertical chimneys on the exterior and dominant fireplaces on the interior. "It [the fireplace] demarcates but does not rigidly separate the living- and dining-room areas, which are united by open corridors and shared banks of windows" *(London 1991, 132).*

See:
Hearth

Total design unity was Wright's goal. Thus, he and other Chicago school architects designed furniture, stained glass, ceramics, lighting, and textiles. For example, the diamond shapes are echoed in the windows, table lamps, and runner scarves in the dining room of the Robie House, now part of the University of Chicago; the rectangular motif characterizes the furniture and other textiles; and the horizontal lines of the table, mouldings, cornice, and inglenook define the space.

See:
Concrete
4. Frank Lloyd Wright
Decorative Arts
4. Architecture
5. Hull-House
Women
3. Chicago Women

The Renaissance Society is located on the campus of the University of Chicago.

❺ The 1893 World's Columbian Exposition

The World's Columbian Exposition was considered an ideal city.

Frank Lloyd Wright and other Prairie School architects, including the Griffins, were introduced to non-Western cultures, such as those of Japan and ancient Mexico, at the 1893 world's fair.

The World's Columbian Exposition was the first world's fair to have a building devoted solely to women; it was also designed by a women—Sophia Hayden.

See:
Women

❻ Prairie

"Chicago and the lands lying several hundred miles to its west had orginally been covered by plants of the tallgrass prairie: wild rye, slough grass, switch grass, the bluestems, and others. Growing in the lush abundance of a wee-watered land,

grasses like the bluestem could rise over six feet in height..." *(New York 1991, 213)*.

❼ Prairie School

Around Frank Lloyd Wright emerged a group of architects in the Chicago area, Walter Burley Griffin and Marion Mahony Griffin among them, who developed a new design approach during the years 1900–15. This approach consisted of "complex open plans which allowed for a free flow of space between entry, living and dining room, horizontal massing, the conscious integration of house into the landscape, and emphasis on craft..." *(Melbourne 1988, 20)*.

See:
Australia
3. Architecture

❽ Marion Mahony Griffin

Marion Mahony Griffin was a key draughtsperson in Wright's Chicago office until it closed in 1909.

 She designed furnishings in integrated interior-design schemes for some of her projects.

 She closely identified with a "philosophical tradition of natural democracy exemplified in the writings and works of Thoreau, Olmsted, Jensen, Sullivan, James, Whitman, and Wright, all of whom believed a close connection with nature essential to American civilization" *(Melbourne 1988, 16)*.

See:
Authenticity
4. Attribution to Marion Mahony Griffin

See:
Decorative Arts
1. Architecture

Hearth
4. Architecture

See:
Writing
6. American Transcendental and Reform Authors

❾ Walter Burley and Marion Mahony Griffin

The Griffins found independence from Frank Lloyd Wright as well as a sense of democracy and a spirit of utopia in Australia. In their work, we see a struggle "against 'materialism,' the harsh cities of competition and the myth of progress. Their confrontational stance was coupled with a desire to draw nature and society together in architecture, to engage both the forest and the inner city, and produce architecture that, in its monumental force, could be applied in urban, suburban, or rural settings" *(Melbourne 1988, 40)*.

See:
Cities
2. Australian Capital
3. Castlecrag
5. Cities in India

Australia
3. Architecture

❿ International Style

Coined in 1932, the International Style referred to the widespread use among industrialized nations of a design based on geometric, linear forms that contained open spaces. It was characterized by cantilevered construction through the use of ferro-concrete floor slabs and glass walls. An appearance of clarity and precision was achieved through a lack of ornamentation. The presence of Mies van der Rohe in Chicago made this city a major site for the development of the International Style.

See:
Concrete
3. Chicago

Australia
3. Architecture

⓫ Frank Baum

This author began his creative life in Chicago by designing store window displays. The steel-frame construction of modern architecture as developed in Chicago beginning in the 1880s allowed for larger windows. Baum is best known for his

fictional work *The Wizard of Oz*. Australia has popularly been called "Oz."

● **References**
a freestanding wall in an open gallery, a wall painting design, a concrete mantel, wood book rack, Marion Mahony Griffin's writings rendered in petit-point; an International Style painting of a modern city; the harmony of objects in the installation

CITIES

❶ **United States Capital**
New York was the capital of the United States for about a year, and then it moved to Philadelpia for a decade. In 1800, the capital was moved to the District of Columbia, a ten-mile-square plot of land ceded by Maryland and Virginia. It stands about halfway between the northern and southern points of the nation.

❷ **Australian Capital**
In 1911, King O'Malley, an American emigré serving as Minister for Home Affairs, began plans to build a federal capital in Australia. The government selected a site midway between Sydney and Melbourne on the fringe of the Australian Alps. Ostensibly the site inland was chosen to protect the city from naval bombardment, but the political risk of choosing one existing city to be capital over all others may have influenced the selection of the site as well. Australians turned to Washington, D.C., both as inspiration and as a lesson in poor city planning *(Melbourne 1986, 82–3)*.

See:
Concrete
2. Walter Burley Griffin
Hearth
4. Architecture

Inspired by Rudolph Steiner's anthroposophy communities and Walt Whitman's ideas about modern spirituality, the Griffins looked for new forms and images that would reflect social plurality, American individualism, and democracy. The rock crystal became a central ordering form in their work in Canberra and public projects thereafter. By linking their crystal forms to groups of other shapes, the Griffins formed miniature cities within the larger city of Canberra *(Melbourne 1988, 37)*.

"It is not a soul that Canberra lacks, although it would take a major metaphysician to locate the thing; it is more a sense of purpose. Canberra, like many capital cities (and not only the modern ones like Brasilia; Asia is littered with ruined capitals which were built purely for the aggrandisement of the rulers of

the time), is an artificial city. It was constructed not around any existing industrial, transport or rural settlement, but simply out of thin air....a common complaint from tourists is that they can never find the centre of town. You frequently hear this complaint from those who are actually standing in it at the time....Visitors are impressed or bemused by the city's uncluttered, circular road system that often has a tendency to lead the unwary around in circles....It is a strange place, conceived by accident, built by bureaucrats, on the way from nowhere to nowhere" *(Sydney 1988, 137–39).*

See:
Decorative Arts
1. Arts and Crafts Movement

❸ Castlecrag

After he lost his political office, King O'Malley became a Sydney land developer and hired Walter Burley Griffin to design Castlecrag *(Melbourne 1986, 88).*

"Castlecrag, the idealistic Sydney suburb,...expressed in physical form the anthroposophical ideas that Marion Mahony Griffin held so dear"*(Melbourne 1988, 16).*

According to Marion Mahony Griffin, "Castlecrag became not simply a special suburb demonstrating the benefits of integrating the built and the natural environment, but also an expression of spiritual truth" *(Melbourne 1988, 19).*

"The Griffins adopted Anthroposophy because it was more progressive, individualistic, pluralistic, cerebral and free of anti-Christian bias than was theosophy. It is also likely that the nature-oriented philosophies in their work on Canberra had failed them, and that Marion in particular saw the possibility in a religion which stressed human rather than devine sources of wisdom....the Griffins' house and Castlecrag became Sydney's centre of anthroposophical activities" *(Melbourne 1988, 19).*

See:
Chicago Architecture
3. Louis Sullivan
6. Prairie

❹ Grid

In Chicago in 1830, civil engineer James Thompson prepared a plan of Chicago. "Working with straight lines and right angles, the rigid geometry of a practical man, he imposed an efficient man-made order on the curves and undulations of the glacially formed land. His would be a straightforward town, a businesslike town (*Chicago 1988, xiii).*

See:
Concrete
2. Walter Burley Griffin
Shoulder
2. Chicago

The City Beautiful movement "challenged the materialism that many Americans saw enshrined in the American grid plan, by laying over it diagonal parkways and avenues" *(Melbourne 1988, 31).*

See:
Hearth
4. Architecture
Decorative Arts
2. Weaving

❺ Cities in India

In a letter to Genevieve Lippincott on February 13, 1937, Marion Mahony Griffin wrote: "Walt felt very definitely that India offered far greater opportunities than Austrilia. India is a very busy place and in the next half century may undergo the transformation the last century saw in America and Europe. For a century ago there was no such thing as a big city in our modern sense of the word."

❼ London

William Morris imagined a pastoral and idyllic London in the year 2090. According to Morris, "The new London bears little resemblance to the old; it has become an agglomeration of villages separated by woods, prairies and gardens, and the ugly houses, dirty with soot, have been replaced by beautiful cottages and buildings" *(New York 1950, 257, 260).*

See:
Decorative Arts
1. Arts and Crafts Movement

● References

a painting that may represent Chicago, New York, Melbourne, or another urban center

CONCRETE

❶ History and Eternity

Concrete is the oldest synthetic material used in buildings; the Romans used it in the foundations of the Temple of Concord, finished in Rome in 121 B.C., and eventually used it for walls, domes, vaults, and breakwaters. It was also used by Mayan builders in the eleventh century *(Chicago 1971, 155).*

"Concrete means stone and Stone spells eternity...The development of methods to manufacture great quantities of synthetic stone has given our present civilization the durability it so much needed...has removed, in large degree, the serious menace to life of a coming timber famine...given us the essential material on which to found our prosperity" *(Chicago 1924, 190).*

❷ Walter Burley Griffin

In the auditorium of the Griffins' capitol building in Melbourne, "the audience was confronted with the building's concrete construction, now expressed as living rock..." *(Melbourne 1988, 31).*

Griffin patented a system of "knitlock" concrete, a lightweight building block that resembles dressed stone *(Melbourne 1988, 32).*

❸ Chicago

George A. Frear began the first commercial manufacturing of precast concrete block in Chicago in 1868 *(Chicago 1971, 158).*

Concrete is an American industry. In 1902 a group of cement manufacturers banded together and formed the Portland Cement Association to establish

concrete as an American industry and stave off foreign competition.

Chicago became the national headquarters of the Portland Cement Association, a service organization dedicated to educational and research work, in 1916. From there it disseminated new information to its many district offices. The association also has a section devoted to concrete house promotion.

The spring meeting of the association opened in Chicago on May 8, 1916. It was the first gathering of the membership since it adopted its plan of increased activities. "Soft Shoulder" opened at the Renaissance Society in Chicago May 8, 1994. It was the first day the exhibition was on view *(Chicago, 1924, 229)*.

❹ Frank Lloyd Wright

"What about the concrete block? It was the cheapest (and ugliest) thing in the building world. It lived mostly in the architectural gutter as an imitation of rock-faced stone. Why not see what could be done with that gutter rat? Steel rods cast inside the joints of the blocks themselves and the whole brought into some broad, practical scheme of general treatment, why would it not be fit for a new phase of our modern architecture? It might be permanent, noble, beautiful" *(Carbondale 1988, 68)*.

"Perhaps no material held more promise than the concrete block for translating into reality Wright's conclusion that the strength of the democratic system depended on the independent stake of each individual in the system—each family in its own home on its own ground" *(Carbondale 1988, 145)*.

See:
Chicago Architecture
2. Democracy
4. Frank Lloyd Wright
Decorative Arts
5. Hull-House

❺ Cloth

Concrete is shipped throughout the world in cloth sacks. The first meeting of the Portland Cement Association in 1902 dealt with "the present methods of handling the subject of sacks, which are almost universally unsatisfactory."

See:
Decorative Arts
2. Weaving
Women
2. Jane Addams

⬤ References
a concrete shelf

COPPER

❶ Conductor
Copper is an excellent conductor of electricity and heat. It can be used to shield buildings from interference caused by incoming radio waves.

❷ Coins
Copper has been used in coins since ancient times. It is a medium of exchange and a symbol of wealth.

Copper was used for the minting of the first U.S. coins, a cent and half-cent piece; the copper penny is now mostly zinc, though it retains the same shiny copper color; copper has been added to dimes, quarters, and half-dollars, all formerly made of silver. There are Australian one- and two-cent pieces and dollars made of an alloy of copper, aluminum, and nickel.

❸ Mining
Copper is mined in the U.S. and Australia. Australia has developed new smelting processes that reduce air pollution.

❹ Printing
See:
Writing
7. Publishing
Copper is used in making engraving plates for the printing industry. Its alloys are also used in other aspects of the printing industry and in the manufacture of paper.

Chicago was a center of the American printing industry.

❺ Pigment
Copper oxide is a red pigment used in the manufacture of glazes on porcelain and ceramic materials.

❻ Plumbing
Copper does not corrode easily, so it is ideal for domestic uses like water pipes. It is expensive, however.

❼ Narelle Jubelin
See:
Decorative Arts
2. Weaving
7. Wedgewood
This artist has often used coins in her art to connote trade, nationality, and the paths of colonization. In 1991 she also rendered in petit-point copper slave tags made in Charleston, South Carolina, and held in public collections in Charleston and Chicago.

● References
a copper-colored set of Wedgewood, a plumbing sign, copper plates

DECORATIVE ARTS

❶ **Arts and Crafts Movement**

Inspired by the "craftsmen ideal" of John Ruskin, William Morris started the Arts and Crafts movement in England in reaction against industrialization, urbanization, and modernization. Uniting art and labor, it was seen as a means of transforming the moral and spiritual fabric of society.

See:
Chicago Architecture
8. Marion Mahony Griffin
9. Walter Burley and Marion Mahony Griffin
Cities
2. Australian Capital

William Morris (1834–96), English poet, artist, and craftsman, published *News from Nowhere*, a utopian novel, in serial form in *Commonweal* in 1890. The work was inspired by his conception of fourteenth-century England, a time "when communities were still small enough to allow bonds of friendship to exist between their members, when workers produced for the restricted market of the city, when craftsmen did not execute other people's plans but those of their own creation..."

See:
Chicago Architecture
2. Democracy

❷ **Weaving**

Nineteenth-century British craftworkers were primarily women, who did traditional work such as lacemaking, spinning, weaving, and knitting *(London 1991, 19)*.

Marion Mahony Griffin prepared the drawings for the Canberra proposal on tontine, better known as Holland blind fabric (Melbourne 1988, 22). She also often made architectural renderings on silk, satin, and linen. "In order to pursue the impenetrable bachelor she volunteered to join his [Walter Burley Griffin's] office part time to make the beautiful series of colored renderings on silk..." *(Chicago 1966, 19)*.

❸ **Home Industries Movement**

Proponents of the home industries movement had no sympathy for Morris's socialism, which they felt threatened their social stability. Rather, their success "was due to the leadership of the upper classes, the involvement of a new moneyed middle class eager to find and express its role in society, and the commitment of both to workforce welfare and, by extension, public awareness....The settlement house movement, providing accommodation, group craft classes and fellowship, formed a counterpart to the rural home industries...It reached its peak during the early and mid-1880s when, for example, Toynbee Hall was founded....Their goal was to redirect leisure hours that might be spent drinking and gambling, to provide aesthetic stimulation, and create objects that might beautify the home" (London 1991, 19, 21–22).

See:
Women
2. Jane Addams

❹ **Architecture**

William Morris regarded architecture as the primary art form to which all others related.

The Arts and Crafts movement created the climate in which Frank Lloyd Wright's work could flourish, though he differed in his approach to handcraft. In his famous lecture delivered at Hull-House in 1901, he pleaded for the creative use of the machine in design and set the Arts and Crafts movement on a new course: "The Machine does not write the doom of Liberty, but is waiting at man's hand as a peerless tool...the creative Artist will surely take it into his hand...." He saw in the machine the ability to promote a democratic art, design that could be made available to rich and poor alike.

See:
Chicago Architecture
2. Democracy
4. Frank Lloyd Wright

The American craft movement flourished in the Midwest, in part through its association with the Prairie School of architecture.

See:
Chicago Architecture
7. Prairie School

Traveling from England, C.R. Ashbee wrote in 1901: "Chicago is the only American city I have seen where something absolutely distinctive in aesthetic handling of materials has been evolved out of the industrial system" *(Salt Lake City 1980, 159)*.

❺ Hull-House

Created out of the settlement movement, Hull-House within a few years of its founding in 1889 was the most accomplished and famous counterpart of Toynbee Hall. "It was the residents of Hull-House and not the trustees of the Art Institute who brought the arts and crafts to Chicago" *(Philadelphia 1986, 47)*.

See:
Women
2. Jane Addams

Architects Allen and Irving Pond worked with Jane Addams and Ellen Gates Starr to expand their operations from the original Hull Mansion into a complex of twelve buildings covering a full city block.

See:
Chicago Architecture
3. Louis Sullivan

Frank Lloyd Wright, among other Chicago-based architects, founded the Chicago Society of Arts and Crafts at Hull-House in 1897 and called for a "just" sense of beauty. "It embodied the crusading zeal of the social settlement residents, the wealthy women who backed them, and the University of Chicago professors whose extension courses spread the message of Ruskin, Morris, and non-Marxian socialism..." *(Philadelphia 1986, 46)*.

See:
Chicago Architecture
2. Democracy
Women
2. Jane Addams

Wright's views were supported by Jane Addams, who advocated "workplace cooperation as a strategy to end individual alienation without eliminating either machine production or division of labor" *(Philadelphia 1986, 47)*.

See:
Women
2. Jane Addams

❻ Narelle Jubelin

Jubelin's harmonious use of decorative arts items — carefully arranged and formally balanced according to shape, materials, color, and other elements of design — and their placement upon a mantelpiece-like shelf relates this exhibition installation to both museum display practices and home interior design.

See:
Authenticity
3. Artistic License
Chicago Architecture
4. Frank Lloyd Wright
8. Marion Mahony Griffin

❼ Wedgewood

It is said of Josiah Wedgewood, founder of the Wedgewood company in the eighteenth century, that "he was the greatest man who ever, in any age or in any country, applied himself to the important work of uniting art with industry" *(New York 1975, 47)*.

Wedgewood commemorated people and events in ceramics.

Wedgewood created a Botany Bay medal that included the figure of Hope. Wedgewood was an ardent supporter of and benefactor to the Anti-Slavery Committee. His company modeled a cameo of a kneeling slave in chains with the inscription: "Am I not a man and a brother"; thousands were made and distributed free to promote "the cause of justice, humanity, and freedom." Benjamin Franklin, who received a parcel, remarked that it "may have an effect equal to that of the best written pamphlet" *(New York 1975, 45–6)*.

See:
Concrete
4. *Frank Lloyd Wright*

Hearth
1. *Wedgewood*

See:
Writing
1. *Autobiography*

See:
Australia

See:
Copper
7. *Narelle Jubelin*

Writing

● References

a wall painting in a geometric grid pattern, Arts and Crafts-style book rack, petit-points, Wedgewood china, a 1960s ceramic bowl, machine-knitted stockings, copper plates thought to be made in a crafts workshop at Hull-House

HEARTH

❶ Wedgewood

In the late 1770s Josiah Wedgewood began to produce delicate ceramic cameos made from basalt and jasper set into marble and wood fireplace surrounds *(New York, 1989, 31)*.

See:
Decorative Arts
7. *Wedgewood*

❷ Arts and Crafts

During the Arts and Crafts movement, William Morris based his fireplace designs on simple, traditional English cottage or country farmhouses of the sixteenth and seventeenth centuries, in which mantels were unadorned separate pieces of slate or wood *(New York 1989, 45)*.

See:
Decorative Arts
1. *Arts and Crafts Movement*

In Red House, the home Morris had built for himself and his wife in 1859, the fireplace was brick with some sections set in a herringbone pattern.

❸ America and Australia

The evolution of the fireplace in Australia followed similar lines to its

development in America and, like in the U.S., is popular today *(New York, 1989, 54–57)*.

Fireplaces are a domesticizing element that create a sense of intimacy and warmth in the home. It brings us back to nature, to the earliest civilizing forms of human contact. In spite of modern, twentieth-century central heating, the open fireplace has been a constant architectural feature of home in Britain, North America, and Australia *(New York 1989, 9)*.

❹ Architecture

"The most notable revolution of the [sixteenth] century directly related to the subject of fireplaces was the emergence of the first trained architects, professionals who were entirely responsible for design and construction" *(New York, 1989, 17)*.

See:
Chicago Architecture
4. Frank Lloyd Wright

Frank Lloyd Wright believed that the fireplace was the foundation of the house, often constructing it on a bedrock which rose into the room, and that it was the symbolic center of the family.

See:
Cities
4. Grid

Decorative Arts
2. Weaving

Marion Mahony Griffin designed the fireplace wall for the 1913 Blythe House, Mason City, Iowa, in a geometric grid pattern of glass tiles.

See:
Chicago Architecture
8. Marion Mahony Griffin

"In the informal competitions Wright held for the minor parts of the building—the mosaic patterns of the fireplaces, murals, interiors and furniture—Mahony often took the prize" *(Melbourne 1988, 20)*.

❺ Mantel

See:
Decorative Arts
2. Weaving

A shelf above a fireplace; a loose, sleeveless coat worn over outer garments.

● References

a continuous concrete mantel shelf; wall painting in a geometric grid pattern

SHOULDER

❶ Soft Shoulder

In both the U.S. and Australia, signs reading "soft shoulder" indicate the need to slow down where the road falls off.

"Soft shoulder" also connotes a sexy female.

The artist uses this phrase to indicate the need to slow down and read carefully the narratives and associations created among objects, as well as to provide a female reference.

❷ Chicago
Hog Butcher for the world,
Tool Maker, Stacker of Wheat, Player with Railroads and the Nation's Freight
Handler;
Stormy, husky, brawling,
City of the Big Shoulders

See:
Chicago Architecture
2. Democracy

Cities
4. Grid

Writing

 Carl Sandburg, *Chicago Poems*, 1916.

❸ White Shoulders
Your white shoulders
I remember
And your shrug of laughter.

Low laughter
shaken slow
From your white shoulders

See:
Women

Writing

 Carl Sandburg, *Chicago Poems*, 1916.

● References
a shoulder-height shelf; a self-portrait created by embossing and images rendered
in petit-point, to be viewed from the side–that is, over one's shoulder

WOMEN

❶ Arts and Crafts Movement
Arts and Crafts dignified traditional women's skills, particularly those of weaving
and needlework.

See:
Authenticity
4. Attribution to Marion
Mahony Griffin

Decorative Arts
2. Weaving

❷ Jane Addams
Jane Addams has been characterized as a middle-class American woman looking
for a mission. "The influential Jane Addams viewed spinning, weaving, and other
'primitive' crafts as means to larger ends. First, by cultivating the immigrants'
handicraft skills, Addams hoped to restore self-respect among people living in a
hostile and alien industrial city....Thus pride in 'women's primitive activities,' as
Addams called the old manufacturing processes, would bring mothers and daugh-
ters closer together, strengthen family life, and ultimately adjust immigrants to the

industrial city" *(Philadelphia 1986, 131–32).*

❸ Chicago Women

Many fashionable Chicago women became involved with crafts; one was Frances M. Glessner, who studied at Hull-House and turned the conservatory of her H.H. Richardson home on Prairie Avenue into her silversmithing workshop.

Frank Lloyd Wright's mother was an early volunteer worker at Hull-House.

❹ 1893 World's Columbian Exposition

The Women's Building of 1893 showed how much women had accomplished in less than two decades. "American women had not merely revived 'lost handicrafts' but had adapted them 'to new circumstances' by applying the classic rules to indigenous motifs" *(Philadelphia 1986, 116).*

❺ Scale

The politics of scale has served to demean women's work in part because it is traditionally small.

❻ Marion Mahony Griffin

Marion Mahony Griffin was the second woman to graduate in architecture from the Massachusetts Institute of Technology.

Typically, historians see Walter Burley Griffin as the architect, landscape architect, and urban planner; Marion Mahony Griffin as the delineator and designer of decorative details *(Melbourne 1988, 15).*

"As an architect, Marion seems to have been capable only of decorative elaboration. Consistent architectural conceptualization and invention were beyond her" *(Chicago 1966, 22).*

● References

Marion Mahony Griffin's writings and design for a fireplace wall; a self-portrait of a female artist; Anais Nin's letters; Wedgewood designed by Susie Cooper; women's stocking

WRITING

❶ Autobiography

Jane Addams wrote *Twenty Years at Hull-House* in 1910, which described her

motivations for and work in establishing America's most important settlement house. In 1930, she wrote a second autobiographical volume, *The Second Twenty Years at Hull-House.*

Marion Mahony Griffin wrote an autobiography, *The Magic of America,* in which she discussed her work in America, Australia, and India. The unpublished manuscript exists in two versions: one dated September 30, 1949, is in the possession of the New York Historical Society; another, different version is in the Ryerson and Burnham Libraries, the Art Institute of Chicago.

Anaïs Nin wrote her autobiography, *The Diary of Anaïs Nin,* in seven volumes.

See:
Women
2. Jane Addams

See:
Authenticity
4. Attribution to Marion Manony Griffin

Chicago Architecture
8. Marion Mahony Griffin

Women
6. Marion Mahony Griffin

❷ Crosswriting
Crosswriting, by which a reply is written at a ninety-degree angle to and on top of a letter received, was a common technique in the seventeenth to nineteenth centuries. This technique allowed one to make the maximum use of paper, which was scarce, and reduce the number of sheets and weight of a letter, thereby saving on postage.

❸ Correspondence
Eight years' correspondence by Anaïs Nin, beginning in 1968 and ending with Nin's death in 1977, are published in *Letters to a Friend in Australia (Melbourne: Nosukumo, 1992).* Nin's letters display an immediate intimacy even though she had not met Pepperell, with whom she corresponded. It is a one-sided exchange; one must fill in mentally what Pepperell wrote.

❹ Scriptio Continuo
Classical texts were copied in *scriptio continuo,* that is, with the text written without spaces between words and no punctuation, but only line breaks.

Nin's *Spy in the House of Love* begins and ends with the same sentence.

The objects laid out on the concrete shelf can be read starting at any point and continuing around in either direction. Each object is like a word laid out in different rhythms to set up the syntax of the sentence. The form of some are like punctuation (the stockings, for example, have the toe pointing downward on the shelf and look like a long dash; the four copper plates are like three ellipses and a period). These objects form multiple narratives, an open text.

❺ Topic Sentence
A motif of book design used in the earlier part of the twentieth century consisted of an indented topic sentence set off in a different typeface from the main body of the text; it served as a key to the reading of the passage.

An unattributed International Style painting is hung on the wall (the only object not placed directly on the shelf) to serve as a key to the content of the

installation. It points to architectural references, materials (paint, wood, fabric), and a modern geometric style.

❻ American Transcendental and Reform Authors

"This can be seen in their use of the reforming ideas of Henry George and (possibly) Edward Bellamy; the 'enlightenment' Walter sought in the evolutionist writings of Herbert Spencer and the Griffins' American evangelism for 'the individual' and 'democracy.' These interests were all connected with the Transcendentalism proclaimed by Ralph Waldo Emerson, and then by Walt Whitman, in the period 1850–1870....the Griffins drew into their activity a recognition of nature in all its immensity and range, and the hallmarks as well as the symbols and institutions of contemporary society, particularly American society"*(Melbourne 1988, 27).*

See:
Chicago Architecture
8. Marion Mahony Griffin

Cities
2. Australian Capital
3. Castlecrag

❼ Publishing

Ellen Gates Starr was the co-founder of Hull-House in 1889. In order to learn bookbinding and bring the ideals of hand labor into her own life, she became an apprentice in 1897 to the English Arts and Crafts leader and idealist socialist T.J. Cobden-Sanderson. She returned to Hull-House in 1889 to set up a bindery. But materials proved expensive, training for neighborhood residents too time-consuming, and finally her instruction was to the benefit of only a few society women. This and the luxury nature of her production contributed to Starr's growing moral conflict around social service and art.

See:
Decorative Arts
5. Hull-House

Women
2. Jane Addams
3. Chicago Women

"As his [Frank Lloyd Wright's] most gifted delineator, Marion Mahony had prepared many of the drawings for the plates that were included in the folio [the famous 1910 portfolio *Ausgefuhrte Bauten und Entworfe*]" *(Melbourne 1988, 15).*

See:
Authenticity
4. Attribution to Marion Mahony Griffin

Chicago Architecture
8. Marion Mahony Griffin

Marion Mahony Griffin's autobiography, *The Magic of America*, remains unpublished.

Nin's books were difficult or impossible to obtain in Australia. Hence, David N. Pepperell — a writer, publisher, and bookseller in Melbourne — began to write to the author. *Letters to a Friend in Australia*, a compilation of Nin's letters to Pepperell, was published in Melbourne with an Australian copyright but is not in circulation in the U.S.

See:
Australia
4. Commonwealth Customs Censorship

❽ References

a double self-portrait in an Australian frame; the frontispiece from *The Magic of America* rendered in petit-point; personal letters from author and autobiographer Anaïs Nin crosswritten onto gessoed boards; a painting hung above the shelf as a key to the installation; a plumbing sign

CODA

●

This text about the Australian artist's work "Soft Shoulder" is written from the authors' Chicago perspective.

● References

stockings made in England, purchased in Sydney, and laid out as if to be packed for a trip; letters from Anaïs Nin sent from the U.S. to David N. Pepperell in Melbourne; a Wedgewood tea and coffee service made in England and purchased in Sydney; a book rack purchased as a gift for a friend; English silver frames for petit-points purchased in Sydney; an Australian's self-portrait made in Tokyo and placed in an Australian frame; an exhibition originating in Chicago and traveling to New York

BIBLIOGRAPHY

Carbondale 1988, Bruce Brooks Pfeiffer and Gerald Nordland, eds. *Frank Lloyd Wright in the Realm of Ideas*. Carbondale: Southern Illinois University Press, 1988.

Chicago 1924, Robert W. Lesley. *History of the Portland Cement Industry in the United States*. Chicago: International Trade Press, 1924.

Chicago 1966, David T. van Zanten. *The Early Work of Marion Mahony Griffin*. Prairie School Review 3 (no. 2), 1966.

Chicago 1971, Carl W. Conduit. *American Building: Materials and Techniques from the First Colonial Settlements to the Present*. Chicago: The University of Chicago Press, 1971.

Chicago 1980, Ira J. Bach, ed. *Chicago's Famous Buildings*. Chicago: The University of Chicago Press, 1980.

Chicago 1988, Don Hayner and Tom McNamee. *Streetwise Chicago: A History of Chicago Street Names*. Chicago: Loyola University Press, 1988.

London 1991, Elizabeth Cumming and Wendy Kaplan. *Arts and Crafts Movement*. London: Thames & Hudson, 1991.

Melbourne 1986, Ray Aitchison. *The Americans in Australia*. Melbourne: AE Press, 1986.

Melbourne 1988, Anna Rubbo. *Walter Burley Griffin: A Review*. Melbourne: Monash University Gallery, 1988.

New York 1950, Marie Louise Berneri. *Journey Through Utopia*. New York: Schocken Books, 1950.

New York 1975, Alison Kelly. *The Story of Wedgewood*. New York: The Viking Press, 1975.

New York 1989, Katherine Seppings. *Fireplaces for a Beautiful Home*. New York: Barron's, 1989.

New York 1991, William Cronin. *Nature's Metropolis: Chicago and the Great West*. New York: W.W. Norton & Co., 1991.

Philadelphia 1986, Eileen Boris. *Art and Labor: Ruskin, Morris, and the Craftsmen Ideal in America*. Philadelphia: Temple University Press, 1986.

Salt Lake City 1980, Lionel Lambourne. *Utopian Craftsmen*. Salt Lake City: Peregrine Smith, Inc., 1980.

Singapore 1988, Phil Jarratt, ed. *Australia*. Singapore: APA Publications, 1988.

Sydney 1974, Peter Coleman. *Obscenity, Blasphemy, Sedition: 100 Years of Censorship in Australia*. Sydney: Angus and Robertson, 1974.

NARELLE JUBELIN:

SOFT SHOULDER

Stained wooden bookrack, Australian ca. 1910, purchased in Sydney as a birthday gift for a friend January 19, 1986.

Embossed paper double self-portrait, produced in collaboration with Satoru Itazu in Tokyo 1991, held in stained wooden frame, Australian ca. 1960, purchased and cut down in Sydney 1988.

Suite of six cotton petit-point renditions over blue transcriptions, on ecru Congress cloth, five framed in collected Birmingham silver frames, one in Chelsea silver frame, all ca. 1910–1930, purchased in Sydney 1990–1994. In part, the petit-point renditions revolve around *The Magic of America*, a four-volume manuscript by Marion Mahony Griffin written ca. 1947. After her husband, Walter Burley Griffin, died in 1937 in India, Marion Mahony Griffin returned to Chicago and composed what was to be their professional epitaph. *The Magic of America* was never published and was compiled in two slightly different versions, neither of which can be determined to have preceded the other. One is held in the Miscellaneous Monographs archive of the Ryerson and Burnham Libraries at the Art Institute of Chicago and the other is part of the New York Historical Society archives, now in the collection of the Grey Art Gallery & Study Center, New York University.

> The first petit-point rendition is of a salvaged scrap of paper used to establish Walter Burley Griffin's hand. It contains the annotation "Residence - Benares W.B.G. Archt," and was assembled in the *The Magic of America*.
>
> The second rendition features a thumbnail sketch of Burley Griffin's "knitlock" construction. To bring a more intimate scale, color, and texture to the knitlock buildings, Griffin produced a square concrete roof tile (12" exposed) laid on a diamond or diagonal pattern. Glass and stained wood were the inevitable companions to the knitlock wall and roof tiles.
>
> The third is taken from the volume frontpiece for the manuscript *The Magic of America*, section IV - The Individual Battle, Walter and Marion Themselves, dated in pencil September 30, 1949. The remaining sections are titled as follows: I - The Emperial Battle, India; II - The Federal Battle, Canberra; III - The Municipal Battle, Castlecrag.
>
> The fourth rendition is the floor plan of the Henry Ford Project of 1912 from the archives of Northwestern University, Evanston, Illinois. (A friend recalled a wall text accompanying this plan in a Frank Lloyd Wright exhibtion that described Marion abandoning or losing the Ford contract and another architect being engaged to build over her already laid foundations.)

The fifth rendition is a detail from "A Home to be Proud of," a review of the Griffins published in *The Pioneer*, India, March 15, 1940, pp 23–27. The review was held within the *The Magic of America*. Any references linking the Griffins to Frank Lloyd Wright were blackened out.

The final rendition is a detail from a 1910 drawing of the G.B. Cooley dwelling, (built 1926), color on linen 36" x 25" from the collection of the Mary and Leigh Block Gallery, Northwestern University. It depicts Marion's method of stippling over Walter's signature on her presentation drawing. In this case, unlike others, she had also obscured her own mark (outside rendition detail).

Thirty silver-point transcriptions, cross written onto gessoed Craftwood, of correspondence by Anaïs Nin to David Pepperell from August 23, 1968 until December 19, 1976. The last letter was closed "James Leo Herlihy for Anaïs Nin." Anaïs Nin passed from this world to the next on January 14, 1977. Letters are quoted from *Letters to a Friend in Australia*, forward by David Pepperell, Melbourne, Nosukumo, 1992.

Ten pieces of fine bone china, Pimento C2097, ca. 1960, designed by Susie Cooper, a member of the Wedgwood Group, England. Cups and saucers received as a gift December 24, 1989, further three-piece set purchased in Sydney, August 9, 1993.

Off-white ceramic ellipse bowl with unstained wooden foot, accrued by The Renaissance Society during its tenure in room 105, Goodspeed Hall.

Ascribed Chicago International School painting, unsigned and undated, witnessed in Chicago, June 5, 1993, purchased May 30, 1994.

Two pairs of unworn, brown, machine-knitted, seamless stockings, ca. 1930, one pair marked "Brettle's B. 1. made in England All Wool," both pair purchased in Sydney, December 17, 1992.

PLUMBING sign, enamel-painted wood, purchased in Chicago, June 5, 1993.

Four copper-beaten plates attributed to Hull-House, Chicago, ca. 1910, purchased May 29, 1993.

Double-sided wall painting, flat white acrylic over gouache and layout pencil, design derived from Marion Mahony Griffin's geometric-pattern tiled fireplace of the 1913 Blythe House, Iowa, illustrated in "Prairie School Architecture in Mason City: A Pioneer Venture in City Planning" by Gerald Mansheim, published in *The Palimpsest*, Iowa, 1987.

Continuous shelf, cement tooth finish, set at 4' x 6 1/2" shoulder height, 5' 1/2" x 12" exposed.

NARELLE JUBELIN

born: 1960, Sydney, Australia
lives in Sydney

EDUCATION

1979–1982
Bachelor of Education in Art, Alexander Mackie College of Advanced Education, Sydney

1983
Graduate Diploma in Professional Art Studies, City Art Institute, Sydney

1988
Artist-in-Residence, South Australian College of Advanced Education

1991
Artist-in-Residence, University of Wolongong, 1991
Australia Council, Tokyo Studio, 1991

INDIVIDUAL EXHIBITIONS

1993
Estate, Galeria Knoll, Budapest

1992
Estate, Galerie Knoll, Vienna
Dead Slow, Centre for Contemporary Art, Glasgow

1991
Cloth, Mori Gallery, Sydney

1989
Second Glance (at the Coming Man), George Paton Gallery, Melbourne;
University of Tasmania Gallery, Hobart

1988
Second Glance (at the Coming Man), College Gallery, Adelaide; Mori Gallery,
Sydney

1987
Re-presenting His Story, Institute of Technology, Architecture Faculty Gallery,
Sydney

1986
His Story, Mori Gallery, Sydney
Remembrance of Things Past Lays Bare the Plans for Destiny, Avago, Sydney

1993
Old Love, with Satoru Hazu, Gallery Lunami, Tokyo

1987
The Crossing, with Adrienne Gaha, First Draft, Sydney

1985
Narelle Jubelin/Paul Saint, Plan Z Gallery, Sydney

COLLABORATIVE EXHIBITIONS

1994
Trade Delivers People, second version, National Gallery of Victoria, Melbourne

1993
Sshhh . . . , Mori Gallery, Sydney

1992
The Boundary Rider, in the *Ninth Biennale of Sydney*, Bondstore, Sydney
Doubletake: Collective Memory and Current Art, Hayward Gallery, London;
Kunsthalle, Vienna
Internal Affairs, in collaboration with Allan Cooley for *Working in Public*,
Philippine Consul General and Trade Offices, Sydney
Molteplici Culture, Convento di S. Egidio, Rome

1991
The Subversive Stitch, Monash University Gallery, Melbourne, and Mori
Annexe, Sydney
Frames of Reference: Aspects of Feminism and Art, Pier 4, Sydney
Foreign Affairs, in *Places with a Past: New Site-Specific Art in Charleston*,
Spoleto Festival, Charleston, South Carolina

1990
Paraculture, Artists Space, New York
Adelaide Biennial, Art Gallery of South Australia, Adelaide
Trade Delivers People, in *Aperto, Venice Biennale*, Venice

1989
Towers of Torture, Tin Sheds Gallery, Sydney
Delineations: Exploring Drawing, Ivan Dougherty Gallery, Sydney
Perspecta 1989, Art Gallery of New South Wales, Sydney

BIBLIOGRAPHY

SELECTED CATALOGUES

1992
Burn, Ian, "The Metropolis is only Half the Horizon," Sydney: Ninth Biennale of Sydney.

Cameron, Dan, "Slow Train Coming," Carolyn Christov Bakargiev and Ludovico Pratesi, editors, Rome: Edizione Carte Segrete.

Cooke Lynne, Bice Curiger and Greg Hilty, *Double Take: Collective Memory and Current Art*, London and Zurich: South Bank Centre and Parkett Verlag AG.

Stephen, Ann, *Dead Slow*, Glasgow: Centre for Contemporary Art in association with the Biennale of Sydney.

1991
Artspace, *Frames of Reference: Aspects of Feminism and Art*, Sydney: Artspace.

King, Natalie, *The Subversive Stitch*, Melbourne: Monash University Gallery.

1990
Broadfoot, Keith and Rex Butler, *The Fearful Sphere of Australia*, Sydney: Artspace.

Ewington, Julie, "Detail: a small exhibition in the environment," Canberra: Canberra Institute of the Arts.

Gertsakis, Elizabeth, "1990 Adelaide Biennial of Australian Art," South Australia: Art Gallery of South Australia.

Johnson, Vivienne, "People Deliver Art," Sydney: Mori Gallery.

Venice Biennale, *XLIV Esposizione Internazionale d'Arte La Biennale di Venezia*, Milan: Fabbri Editori.

1989
Grace, Helen, "The Unforeseeable Object (Petit) d'(a)rt," Sydney: Art Gallery of New South Wales.

1988
Gertsakis, Elizabeth, *Second Glance (at the Coming Man)*, Sydney: Mori Gallery.

Kerr, Joan, "Other Voices: More Stories," London: Commonwealth Institute.

1987
Lindsay, Eloise, Dian Lloyd, Tim Maguire, and Sarah Miller, *The Crossing*, Sydney: First Draft.

SELECTED ARTICLES & REVIEWS

1993
Brauer, Fay, "The Bricoleur—The Borderico—The Post-Colonial Boundary Rider," *Agenda: Contemporary Art Magazine* (Mar., no. 29).
Fenner, Felicity, "Around the Boundaries," *Sydney Morning Herald* (Sat., Jan. 2).
Gertsakis, "A Pure Language of Heresy, The work of Narelle Jubelin," *Binocular/Focusing/Material/Histories,* Sydney: Moet & Chandon Contemporary Edition, Sydney.

1992
Holder, Jo, "International Perspective," The Australian (Dec.).
Losch, Diane, "Subtle Tension in the work of Narelle Jubelin," *Art & Australia* [Sydney] (vol. 29, no. 4).
MacDonald, Murdo, "Maximum from the minimal," *The Scotsman* (Tue., May 5).
Nelson, Robert, "How Subversive was sub ver' sive?," *Object* (Autumn).
Renton, Andrew, "Narelle Jubelin: Dead Slow," *Flash Art International* (Oct., vol. 25, no. 166).

1991
Dinoff, Beth, "History Camouflaged," *Art & Text* (Sept., no. 40).
Kleinert, Sylvia, "On the Idea of Being Subversive," *Crafts N.S.W.* (Summer), 18–9.
Roberts, Clare, "Legacies of travel and trade," *Decorative Arts & Design from the Powerhouse Museum,* Australia: Powerhouse Publishing.

1990
Avgikos, Jan, "Other Relations—The Dangers of Tourism," *Artscribe* (Sept./Oct.), 69–71.
Hanna, Bronwyn, "Marco Polo's Shadow," *From Australia: Contemporary Art and Craft* [Australia Council publication] (no. 2), 21.

1989
Brauer, Fay, "Narelle Jubelin: Second Glance (at the Coming Man)," *Eyeline* (Mar., no. 8), 32.
Brennan, Anne, "Re-drawing the Margins; Looking for Meaning in the Crafts," *Broodsheet* (Autumn, vol. 18).
Delaruelle, Jacques, "Narelle Jubelin, Recent Works," *Sydney Review* (Jan.).
Fox, Paul, "Second Glance (at the Coming Man)," *Transition* [RMIT] (Winter).
Johnson, Annabella, "A Stitch in Time," *Agenda* (Apr., vol. 2 no. 4).
Kerr, Joan, "Bond: Towers of Torture," *Art & Text* (Winter, vol. 31).
Marcon, Marco, "Historicism and Spiritualism," *Australian Art Monthly* (July).
McDonald, John, "Fiona MacDonald: The Presence of the Past/Narelle Jubelin: Second Glance," *Artcoast* (May/June, vol. 1, no. 2), 90–1.

1988

Ewington, Julie, "Broad Australian Accent," *Vogue Australia* (Aug.), 179–81, 194.
Kerr, Joan, "Remaking Hi(s)tory," *Artlink* (vol. 8, no. 3) 29–30.
McNamara, Andrew, "The Crossing," *Photofile* (Summer), 87–88.
Zeplin, Pamela and Tim Morrell, "Language, not just pictures," *Broodsheet* (Summer).

At The Renaissance Society at The University of Chicago this catalogue has been made possible with the generous support of Daryl Gerber and the Elizabeth Firestone Graham Foundation.

The exhibition is sponsored in part by the National Endowment for the Arts, a federal agency; the Illinois Arts Council, a state agency; the CityArts Program of the Chicago Department of Cultural Affairs, a municipal agency; and by the Society's membership. Program support has been received from Qantas Airways Limited, Regents Park by The Clinton Company, The John D. and Catherine T. MacArthur Foundation, and the Andy Warhol Foundation for the Visual Arts. Indirect support has been received from the Institute of Museum Services, a federal agency offering general operating support to the nation's museums.

The catalogue was assisted by the Commonwealth of Australia through the Embassy of Australia, Washington D.C. Research was assisted by the Australia Council, the Australian federal government's arts funding and advisory body.

At the Grey Art Gallery the exhibition and publication are made possible with the support of the Abby Weed Grey Trust and the Friends of the Grey Art Gallery.

ISBN 0-941548-30-9
The Renaissance Society at The University of Chicago

©1994 The Renaissance Society at The University of Chicago
Designed by JNL Graphic Design, Chicago
Edited by Jean Fulton and Hamza Walker
Photographs by Tom van Eynde
Printed by Consolidated Press, Inc., Elk Grove Village, Illinois

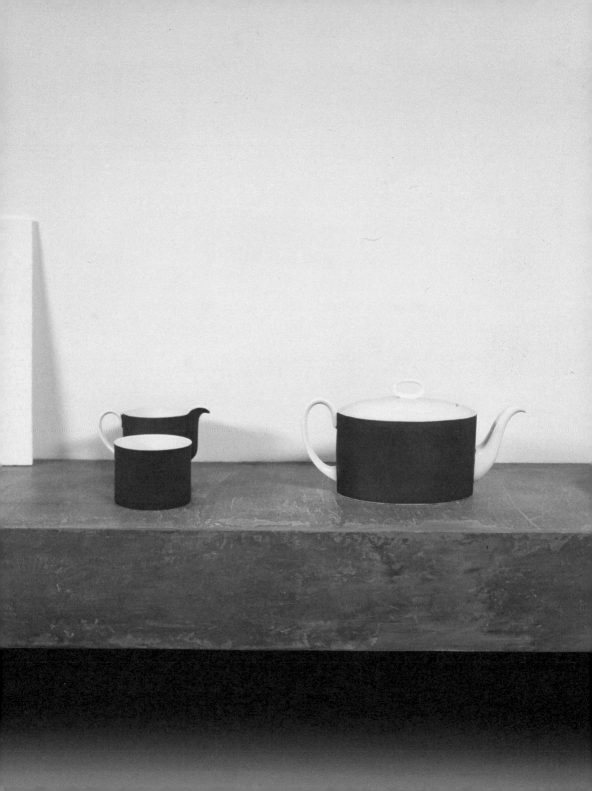